DATE

BF

GUATEMALA

MAJOR WORLD NATIONS
GUATEMALA

Tricia Haynes

CHELSEA HOUSE PUBLISHERS
Philadelphia

Chelsea House Publishers

Copyright © 1999 by Chelsea House Publishers,
a division of Main Line Book Co.
All rights reserved.
Printed in Hong Kong

First Printing.

1 3 5 7 9 8 6 4 2

Library of Congress Cataloging-in-Publication Data

Haynes, Tricia.
Guatemala / Haynes, Tricia
p. cm. — (Major world nations)
Includes index.
Summary: Describes the geography, climate, people, transportation
systems, government, and economy of this Central American country
often called the "Land of Eternal Spring."
ISBN 0-7910-4974-4
1. Guatemala—Juvenile literature. [1. Guatemala.] I. Title.
II. Series.
F1463.2.H38 1998
972.81—dc21 98-6402
CIP
AC

ACKNOWLEDGEMENTS

The Author and Publishers are grateful to the following organizations and individuals
for permission to reproduce copyright illustrations in this book:
Flora Bottomley/South American Pictures; CIRIC/APA; International Coffee
Organization; The Mansell Collection Ltd; Tony Morrison/South American Pictures;
Hallam Murray/South American Pictures; Oxfam Visual Aids Department; Eugénie
Peter; Carlos Reyes/Andes Press Agency; Sean Sprague/Mexicolore; Travel Photo
International; Photothèque Vautier-de Nanxe.

CONTENTS

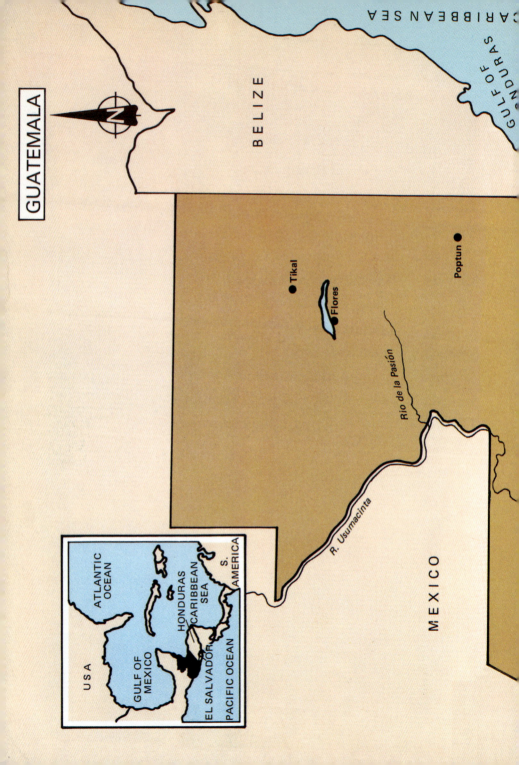

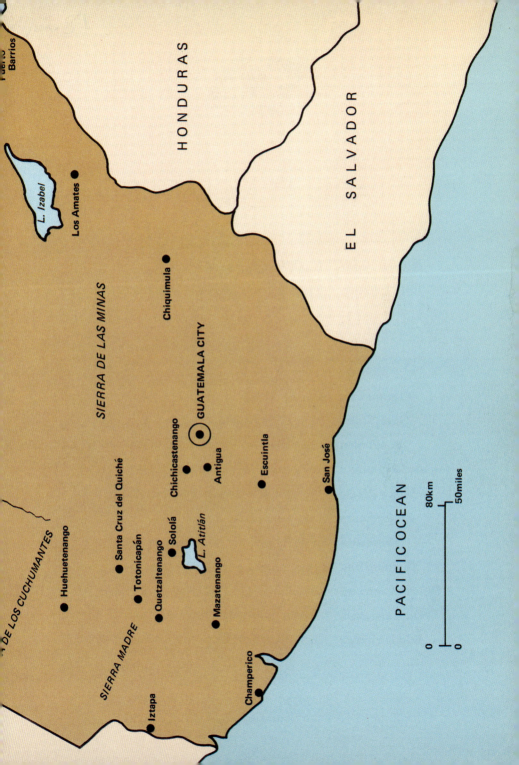

FACTS AT A GLANCE

Official Name	Republic of Guatemala
Location	Third largest country of Central America located in the northwestern corner bordered on the northwest by Mexico
Area	42,042 square miles (108,889 square kilometers)
Climate	Tropical
Capital City	Guatemala City
Other Cities	Mixo, Villa Nueva
Population	11,242,000
Population Density	267 persons per square mile
Major Rivers	Motagua, Usumacinta, Polochic, Chixoy
Major Lakes	Lake Izabel, Lake Atitlán
Mountains	Sierra Madre, Sierra de los Cuchumantes
Highest Point	Volcán Tajumulco (13,815 feet)
Official Language	Spanish
Other Languages	Twenty Amerindian languages
Ethnic Groups	Amerindians (42.8 percent); Ladinos (mixture of

Spanish and Indian) (57.2 percent)

Religions Catholic (75 percent); Protestant (25 percent)

Economy

Natural Resources Petroleum, lead, zinc

Labor Force Agriculture provides employment for over 50 percent of the work force

Agricultural Products Corn, coffee, sugar cane, citrus fruits

Industries Clothing and textile, mining, cattle ranching, fishing, tourism

Major Imports Machinery, chemical products, plastic products, food, metal products

Major exports Coffee, cocoa, bananas, sugar cane, flowers, beef, cotton

Major Trading Partners United States, Mexico, Venezuela

Currency Quetzal

Government

Form of Government Sovereign Democratic Republic

Government Bodies Congress, Supreme Court

Formal Head of State President

Voting Rights All citizens over the age of eighteen

HISTORY AT A GLANCE

30,000 B.C.-1500 B.C.	Primitive hunter-gatherers arrive in the region, which later was to become southern Mexico, Guatemala, and Belize.
2000 B.C.-1000 B.C.	Development of agriculture in region, with small cities, tombs, and an extensive religious cult.
200-900 A.D.	Classic Maya era. The Mayas develop a series of independent city-states, rather than a single empire. Large pyramids are built, a structured society of nobles, priests and peasants is formed along with a written language with a large body of literature. Astronomy and mathematics reach a high level.
700-900	Tikal becomes the greatest city of the Classic Maya period. Today it is Guatemala's most impressive architectural site.
830-930	Collapse of the Classic Maya civilization. The people abandon their cities and return to the jungles. No external enemies are involved; the collapse may have been due to plague, famine or domestic turmoil.
1523	Cortes sends his lieutenant Pedro de Alvarado to

conquer southern Mexico and Guatemala.

1527 Ciudad Viejo founded as first capital of Spanish province of Guatemala.

1541 Ciudad Viejo destroyed by flood from volcanic crater lake, the first of many natural disasters, principally earthquakes, which are to plague Guatemala into modern times.

1543 Antigua Guatemala (as it has been known since 1799) is founded as Guatemala's second capital.

1697 Last Mayan city-state conquered by Spanish.

1701-1703 The Dominican Francisco Ximenez copies into Spanish the Maya sacred book *Popol Vuh*, thus preserving one of the greatest literary treasures of the Americas.

1773 An earthquake on July 29 destroys Antigua Guatemala, and leads to the founding of modern-day Guatemala City. Antigua Guatemala is later rebuilt and remains famous for historic buildings.

1811-1821 A series of revolts, inspired by Simon Bolivar's exploits, topples Spanish rule in Guatemala.

1823 United Provinces of Central America formed on July 1, including Guatemala, El Salvador, Honduras, Nicaragua, and Costa Rica.

1830-1838 As part of United Provinces, Guatemala attempts reforms in economy, treatment of Indians, and church-state relations.

1840 United Provinces of Central America breaks up into separate nations.

1885 War breaks out with Costa Rica, El Salvador and Nicaragua.

11

1906	Guatemala fights a brief war with El Salvador and Honduras.
1931-1944	General Jorge Ubico elected president. Democratically elected, he rules arbitrarily, but attempts many reforms.
1945-1951	The enlightened government of Juan Jose Arevalo. He makes many improvements in social security, health, labor law and Indian affairs. He is succeeded in 1951 by Jacobo Arbenz.
1954	Civilian regime of Jacobo Arbenz overthrown by U.S.-backed military leaders, after embarking on a land reform considered too radical.
1960	Scholars decipher Maya alphabet, leading to more detailed understanding of the ancient culture.
1976	Earthquake kills 22,000 people and leaves another million homeless.
1980s	Political violence continues to escalate, often pitting the wealthy elite of Spanish ancestry against a poor majority of Mayan ancestry. A state of civil war in some rural areas.
1982	General Jose Efraín Ríos Montt comes to power. Political unrest continues and many people, particularly Indians, are killed in random attacks by government forces.
1983	General Oscar Humberto Mejia Victores comes to power, although violence and other conditions in the country remain unchanged.
1985-1990	U.S. pressure brings about civilian government under Marco Vinicio Cerezo Arevalo.
1990	Jorge Serrano Elias is elected president. He has

many ties to the military and far-right groups. He opens negotiations with anti-government guerrillas, but with little success.

1992 Rigoberta Menchu, a Mayan woman, wins the Nobel Peace Prize for her book describing the plight of her people during Guatemala's civil strife.

1993 Jorge Serrano Elias is driven out and the Guatemalan Congress chooses Ramiro de Leon Carpio, a human rights advocate, to fill his unexpired term.

1995 De Leon Carpio regime is not effective in curbing human rights abuses, including murders of U.S. citizens. The United States cuts back aid to Guatemala.

1996 In January, Alvaro Enrique Arzu Irigoyen is elected president. By year's end a peace accord has been signed with the guerrillas, ending three decades of civil war.

1

Land of Eternal Spring

Guatemala is the third largest country in Central America after Nicaragua and Honduras and covers an area of just over 42,000 square miles (108,889 square kilometers). It is bordered by Mexico to the north and west, Belize and Honduras to the east, and El Salvador to the southeast, and has both a Pacific and a Caribbean coastline.

The name Guatemala is thought to come from the American Indian word *Quauhtomallan*, once the name of the capital city of the region. Eventually *Quauhtomallan*, which the invading Spaniards altered to Guatemala, was adopted for the whole country. Today Guatemala is often called the "Land of Eternal Spring" on account of its mild, springlike climate.

Geographically, Guatemala can be divided into several distinct categories. In the east, on the Gulf of Honduras on the Caribbean coast, are lowlands, comprising wooded rises (just over 3,000 feet high or up to 1,000 meters) and plains. On the Pacific coast to the west lie humid plains and lagoons. Here,

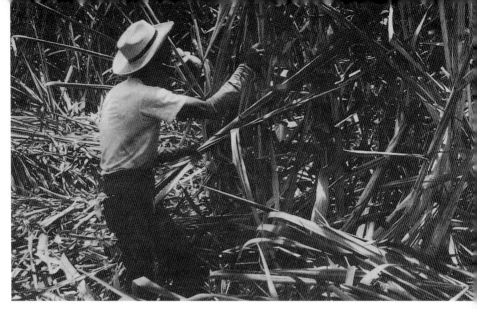

Cutting sugarcane. With the clearing of jungles and swamps, much more land is now available for agriculture.

black volcanic sands from the Sierra Madre mountain range stand out in sharp contrast with the white sands of the Caribbean.

In the north of Guatemala, bordering on Mexico, is the lowland region known as El Petén, once the center of the ancient Maya civilization. This covers one-third of the country's total land area and comprises hot, dense forests. It is not surprising, therefore, that less than one percent of Guatemala's population lives there.

In the center of Guatemala are plains known as the *llanos*. These consist of pastureland and farms. In the past, much of the area was covered in impenetrable and disease-ridden jungles and swamps. These have now been cleared and the *llanos* form

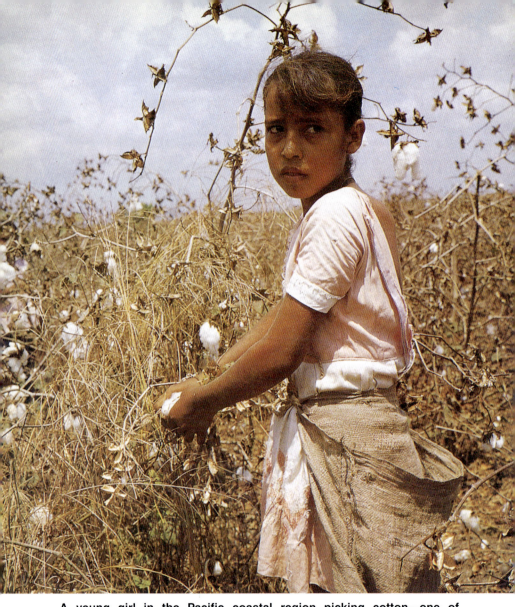

A young girl in the Pacific coastal region picking cotton—one of Guatemala's largest agricultural exports.

Guatemala's agricultural center, growing sugar cane, cotton and bananas. Cattle are raised in this area too, and many ranches are to be found.

Much of the rest of Guatemala is mountainous. The most important mountain range is the Sierra Madre. This begins in the department of Quetzaltenango, close to the Mexican border, and extends parallel to the Pacific coast as far as El Salvador. The Sierra Madre range is over 217 miles (350 kilometers) long and includes more than thirty volcanoes. Pacaya in the central region and Santiaguito in the west are active. Tajumulco, near the Mexican border, is the highest volcano not only in Guatemala but in the whole of Central America, reaching a height of 13,808 feet (4,210 meters). Another important mountain range is the Sierra de los Cuchumantes, which lies in the east of Guatemala. It runs south from the Mexican border roughly as far as the town of Coban, and reaches a height of 12,431 feet (3,790 meters). Two smaller chains, the Sierra de las Minas and the Sierra de Santa Cruz, extend eastward towards Honduras and Belize. Between these two ranges, in the area which lies between Lake Izabel and the Honduran frontier, are the huge banana plantations created by the United Fruit Company.

The chief river of Guatemala is the Usumacinta which, for part of its course, flows along the Mexican frontier. Other major rivers include the Polochic, which flows into Lake Izabel, and the Chixoy and the Rio de la Pasión which both flow into the Gulf of Mexico on the Pacific coast.

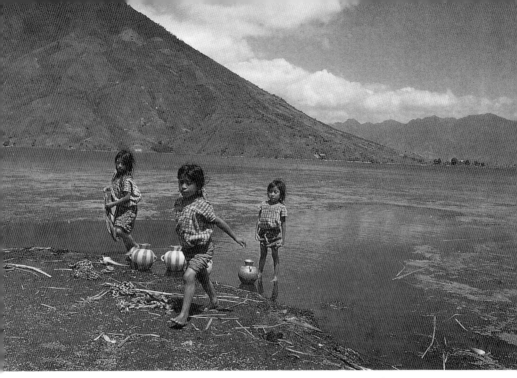

Indian children on the shore of the spectacular Lake Atitlán.

Guatemala has some very impressive lakes. The largest of these is Lake Izabel, 33 miles (53 kilometers) long and 18 miles (29 kilometers) wide. The most spectacular lake of all is Lake Atitlán, surrounded by snowcapped volcanoes.

Because Guatemala lies in the seismic zone (known as the "Girdle of Fire") of Central America, it is threatened by earthquakes. The most serious earthquake in recent years occurred in 1976, when a violent tremor partly destroyed the capital, Guatemala City, killing over 22,000 people and causing about $700 million in property damage.

Guatemala has two main seasons—a rainy season from May to

October and a dry season from November to May. As Guatemala is mountainous, it enjoys a variety of climates from springlike temperatures throughout the year in the highlands to the hot humid weather along the coastal plains. The rainfall varies according to altitude but, as in most tropical countries, can be heavy.

In the coastal plains, temperatures can reach as high as 100 degrees Fahrenheit (38 degrees Celsius) during the day, falling to 68 degrees Fahrenheit (20 degrees Celsius) at night. In Guatemala City between March and May (the warmest months of the year), temperatures may soar as high as 93 degrees Fahrenheit (34 degrees Celsius) during the day, falling to 54 degrees Fahrenheit (12 degrees Celsius) at night. In the highlands, daytime temperatures in the warmer months can rise to 91 degrees Fahrenheit (33 degrees Celsius), while in the cold

The aftermath of an earthquake. Because it lies in the seismic zone of Central America, Guatemala regularly suffers earthquakes—sometimes with devastating consequences.

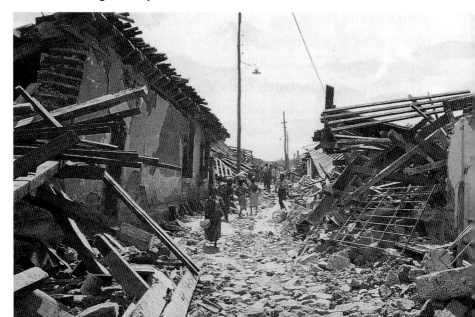

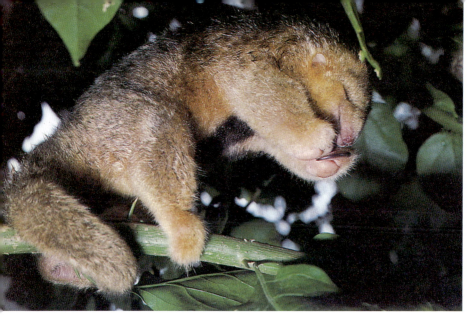

A Little (or Two-toed) Anteater, which lives in the dense tropical forests in the north of Guatemala.

months they vary between 72 and 75 degrees Fahrenheit (22 and 24 degrees Celsius).

Because of these differences in climate, Guatemala's flora and fauna are tremendously varied. There are vast numbers of plants, birds (including the brilliantly-colored quetzal, the national bird), animals and reptiles including snakes, jaguars, monkeys, pumas, armadillos and crocodiles.

Like its climate, Guatemala's population (which stands at around eleven million) is mixed. Guatemala has more people than any other country in Central America, although its population is unevenly distributed. One fifth of the total population lives in the department of Guatemala alone.

Forty-three percent of the people are Amerindians. Most of the

remainder are *mestizos* (people of mixed Indian and European blood). There are also small numbers of Europeans (descendants of the Spanish settlers and of Germans who arrived in the nineteenth century) and Blacks on the coastal plains. The majority of the Indians live in the highlands, relying on agriculture for their livelihood, while the people of European stock reside mainly in the towns.

The official language of Guatemala is Spanish, although Indian communities still converse in their own language. Most Guatemalans are Roman Catholics, although there are also churches of other denominations.

The national emblem of Guatemala is the quetzal, a rare bird

An Indian home in the highlands of Guatemala.

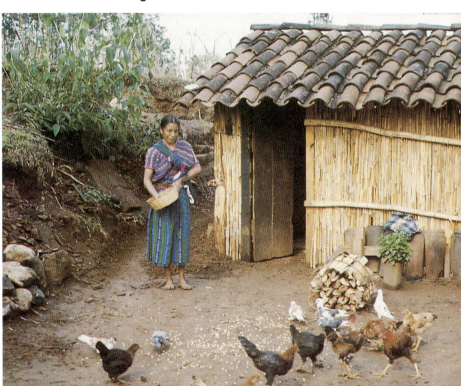

of brilliant green, red and blue plumage. It is considered a symbol of liberty because it dies if captured. Guatemala's national flag is a tricolor of blue, white and blue with the quetzal appearing on the white stripe.

The *quetzal* is also the unit of currency in Guatemala. One quetzal equals one U.S. dollar. There are one hundred *centavos* in a *quetzal*. The bird itself is featured on the coins.

There are a number of public holidays in Guatemala–New Year on January 1st, Labor Day on May 1st, Army Day on June 30th, Independence Day on September 15th, Columbus Day on October 12th, Revolution Day on October 20th and Christmas Day.

Most travellers arrive in Guatemala by air or by road from Mexico. La Aurora, Guatemala's international airport, lies five miles (eight kilometers) south of Guatemala City and has services to main destinations in the United States. Bus services operate from Mexico City and Central American countries such as El Salvador. The Pan American Highway, which links Guatemala with Mexico, has speeded up both traffic and progress.

Guatemala can also be reached by sea. There are cargo ships and some passenger services operate from Europe, Britain and North America to Guatemala's Caribbean and Pacific ports. (Three ports on the Caribbean coast serve Guatemala. They are Puerto Barrios, Santo Tomás de Castilla and Livingston. There are also two ports on the Pacific coast–Champerico and San José.) The Chiquimulilla Canal, running from the port of San

José to the El Salvador border, is important for shipping, and Guatemala has a merchant shipping fleet which operates to New York and European ports. It is also possible to travel to Guatemala by rail from Mexico City, but passengers have to change trains at the frontier.

Travel within Guatemala has improved since the government instituted the National Plan for Economic and Social Development. The aim of the plan is to expand the country's communication and transport system.

The national airline, Aviateca, connects major cities within the country. A narrow gauge railway links Guatemala City with the ports of Puerto Barrios on the Caribbean and San José and Champerico on the Pacific coast.

The most prevalent mode of transportation is bus. Buses are available even to the more remote villages. They are used by the villagers for going to the market towns so they usually run on a schedule convenient for that purpose. The major roads and most of the minor ones are very passable by car and travel by road is still the best way of getting from one place to another.

Modern Guatemala is a very different place from the land inhabited by the Maya, who arrived from the Yucatan (Mexico) in the first century A.D.

2

In the Footsteps of the Maya

The Maya, an American Indian tribe, settled in the northern part of Guatemala, known as El Petén, around A.D. 500. They were already established in the Yucatan (Mexico), Belize and northern Honduras, and they lived by cultivating crops of maize, beans, peppers and cocoa. They were also tireless builders and architects and brought with them the knowledge and skills which had enabled them to construct such fabulous buildings as the Temple of the Sun and Moon at Teotihuacan, just outside modern-day Mexico City.

The heart of their empire in Guatemala was Tikal, where more than three thousand buildings, including temples, once stood. There were two periods of Maya culture—the Early Classical, which dated from 250 to 550 A.D., and the Late Classical, from 550 to 900 A.D. The buildings in Tikal date from this Late Classical period, although the Maya's habit of building over old sites makes it difficult for archaeologists to date some of their edifices precisely.

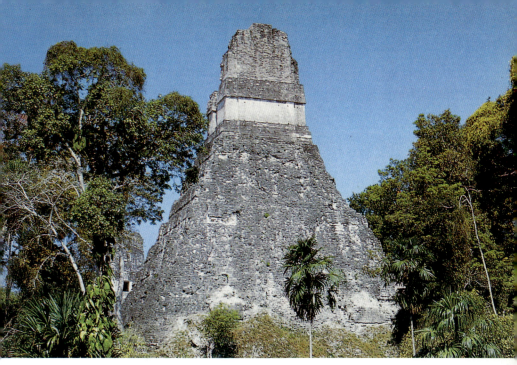

The ruins of Tikal, surrounded by dense jungle.

The Great Plaza (square) at Tikal formed the center of the city.
It is bounded by the Temple of the Grand Jaguar (Temple I) and
the Temple of the Masks (Temple II). Both temples are pyramid-
shaped and are entered by way of a steep flight of external steps.
The Maya worshipped the jaguar, as they had been hunters
before turning to agriculture, and their temples were often
dedicated to these animals. The Temple of the Masks relates to
the masks which the Maya wore for ceremonies and religious
rituals. Both temples have the jaguar and masks carved on the
door lintels.

A short distance from the main plaza of Tikal is Temple IV. At

25

212 feet (65 meters), this is the tallest known building in the Maya world. The front stairway of this immense temple has been overtaken by the jungle, but one glance is sufficient to give an idea of the Maya's amazing civilization and skills.

Traces of the Maya can also be seen at Naranjo, east of Flores (the principal town in the department of El Petén); Nakum, one of the oldest Maya cities, east of El Petén on the Mexican border; and Piedras Negras in the west, also on the Mexican frontier.

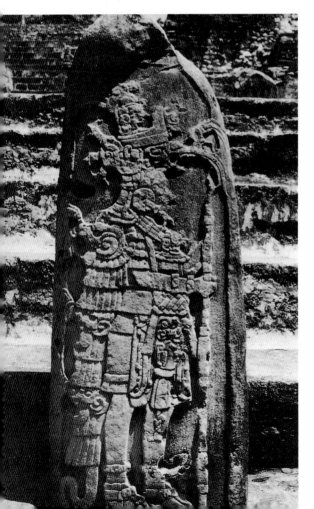

A stele at Tikal, dating from the eighth century A.D., showing a richly-dressed Maya noble.

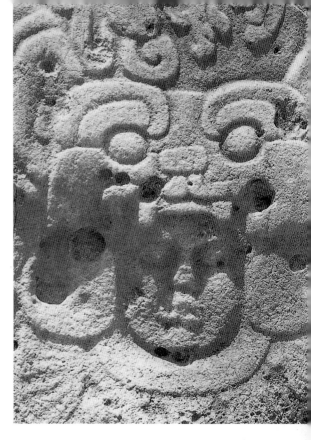

A detail from a stele at Tikal.

Three other important Maya settlements are the Altos de los Sacrificios which was an important religious site (three large stone altars are inscribed with Maya glyphs—ornamental sculptured markings), Ceibal and Cancuen, both noted for their *stelae* (upright stone slabs). At Los Amates, 124 miles (200 kilometers) from Guatemala City, is the Maya city of Quirigua with its 35-feet (11-meter) high *stelae*.

By the year 900, the Maya civilization had ended. The Maya were followed by the Toltecs who worshipped Quetzalcoatl, a god in the form of a plumed serpent. Unlike the Maya, the

27

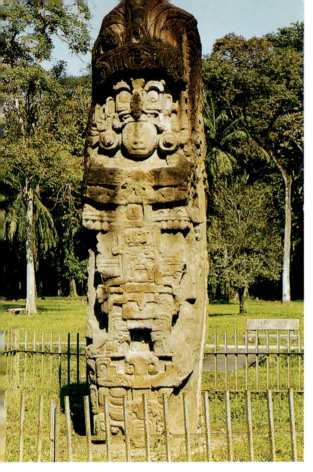

A carved stele at the site of the Maya city of Quirigua.

Toltecs who settled in the area that is now Guatemala were simple, unsophisticated people who were content to cultivate the land. But, in the year 1300, they in their turn were routed by the Aztecs, a warrior tribe originating from Mexico who had crossed the border into Guatemala. The Aztecs, like the Maya before them, were skilled craftsmen and architects, and had founded great cities and temples in Mexico. There are, however, no Aztec remains worthy of note in Guatemala.

In 1521, Hernan Cortes, the Spanish conquistador, marched on the Aztec capital, which was built on the site of modern-day Mexico City, with his army. One of his men, Don Pedro de Alvarado, took a band of followers and continued south into Guatemala. He quickly conquered the Indians, for they were no match for his men. The Indian leader was killed in the ensuing battle and Don Pedro de Alvarado marched on to conquer the rest of the country.

In 1524, he founded Santiago, the first Spanish capital in Central America. Three years later, the capital was transferred to Almolonga, south of what is now Antigua. Stories of Pedro de Alvarado's cruelty in subduing the Indians of Guatemala soon reached Spain. Despite his infamous reputation, however, he was appointed Governor of the Captaincy-General of Guatemala. (In those days, Guatemala extended from southern Mexico to the border between present-day Costa Rica and Panama.) While other Central American countries, such as Costa Rica and Panama, had an abundance of gold, Guatemala had none; and so the Spanish conquistadors in this area had to content themselves with mineral deposits.

In the summer of 1541, Pedro de Alvarado was killed during an Indian uprising in Mexico; his wife, Doña Beatriz, succeeded him as Governor. She was the first woman to hold such high office in Latin America. But disaster was to follow. Less than a week after the appointment, a massive earthquake shattered the capital and Doña Beatriz lost her life.

A new capital had to be built. It was called Antigua. At last, the

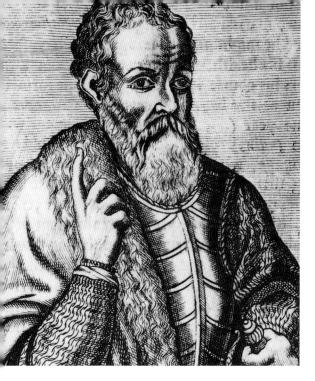

Hernan Cortes, the Spanish conquistador who conquered much of South and Central America.

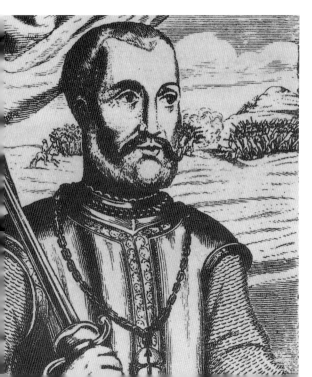

Pedro de Alvarado, the Spanish conquistador who subdued the Indians of Guatemala.

Indians could begin to rebuild their disrupted lives. They cultivated crops, grew cotton, tobacco and cocoa, and planted vast plantations of indigo (a natural dye).

In July 1773, Antigua, too, was badly damaged by an earthquake. This was followed by the eruptions of two volcanoes—Fuego (Fire) and Agua (Water). After so much damage (there had been floods as well), it was moved by royal order to the site of modern day Guatemala City in 1776.

In 1821, the independence of Central America was proclaimed and the Central American Federation was declared. This meant that at last Guatemala had been liberated from Spain. However, Guatemala was still a province of the federation and did not attain full independence until it became a republic in 1847.

Rafaelo Carrera seized control of the government in 1844. In 1851, after the republic of Guatemala came into being, he was elected president; and in 1854 this office was conferred upon him for life.

Central American republics in those days were notorious for their unrest and Guatemala was no exception. However, Carrera's regime, harsh though it was, continued until his death in 1865. His rule was not easy. There were many uprisings, especially by the liberal factions, and these continued after his death. By 1871, new policies had been enforced. Civil liberties were restored and a liberal rule established. But two years later, Guatemala was once again a dictatorship. General Justo Rufino Barrios was elected president in 1873. Initially, his was a liberal regime but, in the face of growing unrest, Barrios was forced, like many leaders before

him, to assume dictatorial powers. Nevertheless, despite the fact that it was a dictatorship, Guatamala had much to thank General Barrios for. Under his leadership, compulsory free education was established. Roads and railways were built. Hospitals and banks were founded. Guatemala's ports became active, establishing trade with other countries. Today in Guatemala, General Barrios is a national hero.

There was to be no simple solution to Guatemala's political and economic problems, however. By the beginning of the twentieth century, these problems had grown worse. One dictator after another came and went. War broke out in Guatemala and extended into neighboring El Salvador and Honduras.

During General Jorge Ubico's rule (he was elected to power in 1931), there was a brief period of stability. It was under Ubico's regime that Guatemalan land was given over to the American United Fruit Company so that banana plantations could be established. These would prove to give a major boost to the Guatemalan economy.

In 1944, just when it seemed as if there would be peace at last, Ubico was overthrown by General Federico Ponce, who was himself driven from office during a revolution. It seemed as if Guatemala would have to face one uprising after another. Apart from the political instability, constant revolutions were having an unsettling effect on the people themselves. Just as one president established hospitals, built roads and tried to form a satisfactory government, he was overthrown.

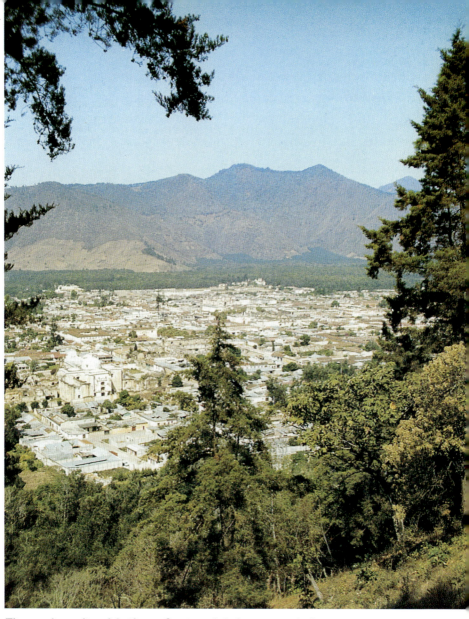

The modern city of Antigua, Guatemala's former capital.

In 1951, General Jacobo Arbenz Guzmán came to power. It looked as if he might succeed where so many others had failed. However, in 1954, after only three years in office, he was forced to resign. A military junta (council) was then declared.

Assassinations, military coups and unrest were the order of the day. When elections were held, there were accusations of ballot rigging, bribery and corruption. Election results were hotly contested. Not only did Guatemala have internal problems, but its relations with other countries were poor. In 1963, Guatemala's relations with Cuba were causing concern. There was also conflict with Britain over Belize (then called British Honduras). Guerilla warfare increased in intensity. Finally, in 1964, Britain granted independence to Belize–amid strong protests from Guatemala, which claimed it had a right to the country.

Meanwhile, guerilla forces were fighting troops inside Guatemala. Regular clashes took place in 1964 and 1965, resulting in yet another general election the following year. Julio Montenegro, the Socialist Party candidate, was duly elected president.

His first task was to make peace with the guerillas, but they refused all entreaties. Montenegro was thus obliged to exercise his political power. However, despite all efforts to suppress it, including severe prison sentences and executions, guerilla activity continued. The political situation was going from bad to worse. After a series of power struggles, Guatemala was obliged to adopt a new constitution as a means of retaining law and order.

This new constitution came into effect in May 1966. It declared

that executive power in Guatemala should be in the hands of the elected president. Civilian government was restored under President Julio César Méndez Montenegro. Both the president and the vice-president are elected for a four-year term, but the president may not be elected for an additional term of office.

It was hoped that under the new constitution there would be no further incidents of ballot rigging and corruption. In 1970, Arana Osorio was elected president and served a four-year term. During his government's term of office, there was less guerilla activity and it seemed as if Arana Osorio had succeeded where Montenegro had failed.

However, under the next president, General Garcia, guerilla warfare broke out again. Between 1970 and 1982 all four of the

The Presidential Palace in Guatemala City.

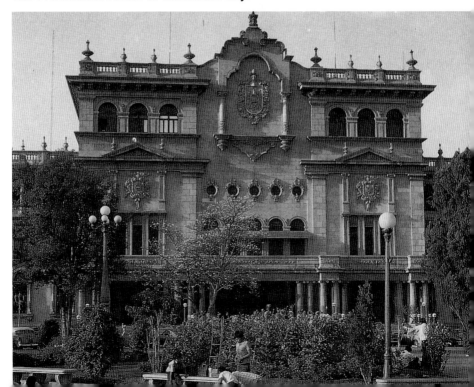

elections were seen as fraudulent. After the 1982 election the government was seized by a three member military junta. The leader of the junta, General Jose Efraín Ríos Montt, suspended the Constitution, abolished the Congress and banned any political party activity. He in turn was overthrown in 1983. In 1985, a new Constitution was written and Congress was reestablished, and a civilian president was elected. Though military leaders tried to again overthrow this new civilian government they did not succeed. In 1991, the president dissolved Congress and declared he would rule by presidential order but Guatemalans would not stand for this and he was removed from office. In 1996, voters elected President Irigoyen who has put a great deal of effort into solving the guerilla warfare problem and restoring peace to this beleaguered country. Today, although Guatemala is relatively peaceful, there is always the danger of further outbreaks—something which might affect not only Central America, but Mexico and the United States too.

3

Traditions and Festivals

Guatemala has been ruled at different times by the Maya, the Toltecs, the Aztecs and the Spaniards. It is not surprising, therefore, that traces of many contrasting civilizations can be seen in the country today. All over the country, Guatemalans like to celebrate their historical roots in festivals, fiestas, processions and parades.

Colonial art was developed by the Spanish conquistadors.

The altar-piece of a Roman Catholic church in Guatemala City.

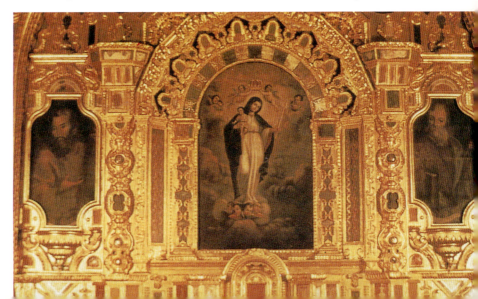

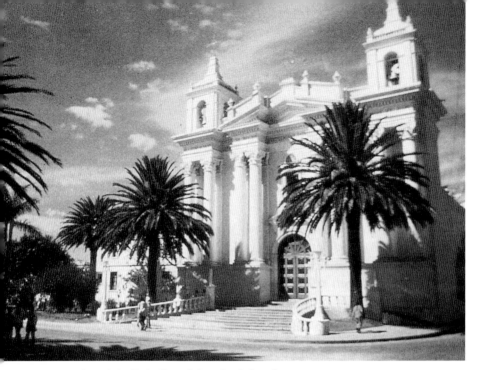

A church built in Spanish colonial style.

They built churches and houses similar in style to those of their home country. Under the Spanish conquistadors, architecture and religious art achieved the highest artistic levels. The sixteenth and seventeenth centuries saw the development of many talented artists and sculptors who carved in both stone and wood, decorating the interiors of churches and creating monuments that would last for generations. However, because Guatemala is situated in the "girdle of fire," earthquakes seriously damaged many such works of art.

More recently, painters have gone back to Maya symbols for their inspiration. Abstract artists have flourished alongside

landscape painters and Indian artists who rely upon their ancient culture for new ideas and concepts.

Writers, too, have used Guatemala's cultural and historic past as a source of material. The well-known writer and poet, Miguel Angel Asturias, is considered to be one of the greatest writers in the Spanish language. His *Leyendas de Guatemala* ("Guatemalan Legends"), written in 1930, concerns the history and lifestyle of the Maya. With such works as *Hombre de Maiz* ("Man of Corn"), Asturias drew attention to the social problems of his country. He wrote of banana plantations, politics and the economy, using sharply defined images to show the extent of human exploitation within Guatemala.

Guatemala has a long musical tradition, too. The *caracol* (a large seashell) and the *ocarina* (a type of flute) are just two of the native musical instruments used in Guatemalan folk song and dance. The Indians used instruments such as these long before the Spanish conquest. They also used the *tambor* (a type of drum) and a percussion instrument known as the *chinchín*, which resembled *maracas*.

The *marimba*, an instrument similar to the xylophone, is frequently seen in Guatemala. These days, *marimbas* vary in size but they were originally small instruments which could easily be played by one person. Today, there are also giant-sized *marimbas* which can be played by a whole group of people. Visitors to Guatemala especially love the liquid sounds of the *marimba*, because it truly characterizes the music of much of Central America.

39

Local fiestas are the place to see good folk dancing, when Indian traditional dress is often worn. Some dances even date back to the days of the Maya Empire but, as many such dances vanished, little is left today to show us how the Maya celebrated. We do know that they celebrated the hunt, so it is quite likely that some of their dances were based on hunting rituals. They also held festivals dedicated to their gods.

On feast days and holidays, dances are often part of street parades. At Santa Cruz del Quiché and also in some of the towns

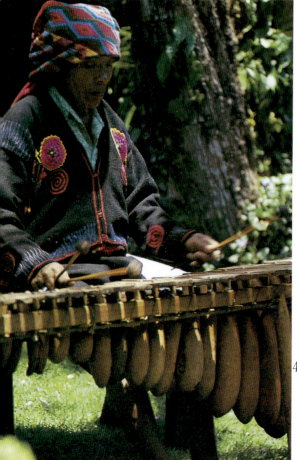

A Guatemalan Indian playing a *marimba* constructed of gourds.

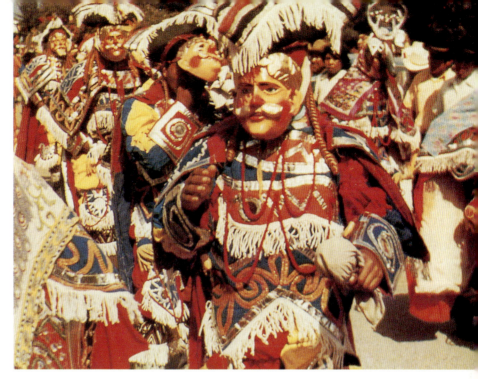

A folk-dance depicting the fierce battles between the Guatemalan Indians and the Spanish conquistadors.

of the department of Quetzaltenago, old dances such as the *gracejos* can be seen. At other fiestas, performers wear masks and colorful costumes as they reenact old rituals from the distant past. The Indian town of Totonicapán specializes in making masks and costumes for fiestas which are held all over Guatemala.

The old capital of Antigua delights in fiestas and celebrates three major festivals every year—*Semana Santa* (Holy Week), Corpus Christi in June, and the *Fiesta de Santiago* in July. *Los Gigantes* (giant human figures dressed as puppets) usually herald a fiesta or celebration.

41

Each year, the villages around Antigua hold a procession in honor of their patron saint. Many religious processions are elaborate, others simple. The big events will include typical Indian dances and firework displays as well as folk music. In the highlands where there were once Maya settlements, ancient folk dances still exist, for tradition in such areas remains strong.

Many Guatemalans today prefer recorded dance music. Although mazurkas, tangos and waltzes can still be heard, it is much more likely that the dance halls will be playing the strident yet compelling rhythms of the *salsa*, a dance highly popular throughout Central America. Young Guatemalans tend to look towards the United States for inspiration in contemporary music, but that is not to say they do not appreciate street carnivals along with everyone else.

Just as there are many different styles of music, so there are various lifestyles in Guatemala. While the descendants of the highland Maya maintain their customs and culture, changing their ways hardly at all to adapt to present-day demands, others prefer the bustle of life in the city.

4

Living in Guatemala

Guatemala is divided into twenty-two departments or administrative areas–Guatemala, Chimaltenango, El Quiché, Quetzaltenango, Sololá, Totonicapán, Huehuetenango, San Marcos, Escuintla, Alta and Baja Verapaz, Zacapa, Chiquimula, Izabel, El Petén, Retalhuleu, Suchitepéquez, Sacatepéquez, El Progreso, Jalapa, Santa Rosa, and Jutiapa.

Their geographical locations make the departments very different. While Alta and Baja Verapaz are coffee-growing areas, the department of Chiquimula is noted for its cattle and fruit. The people of the departments are different, too. The people of small towns and villages lead simple lives, while those in Guatemala City expect life to be much more hectic.

Descendants of the highland Maya still inhabit parts of Guatemala but, although they continue to cling to tradition, their lives are changing. Once such villages could claim one hundred percent pure Indian blood. Spanish was a foreign language, as the Indians spoke in their own tongue. Today, however, such villages are rare. Yet the Indians still manage to

43

maintain much of their independence. They hold their own fiestas, have their own markets and their own customs. They wear Indian dress. They still worship their gods, asking for good harvests. And the women often work on looms weaving the *huipiles* (blouses) and textiles for which Guatemala is famous. Indian weavers use bright colors—the colors of the sun, sky, jungles, birds and flowers which they see around them. Indian crafts are of great interest to visitors, as they have been handed down from generation to generation.

While the Indian communities still live in simple adobe houses, businessmen in Guatemala City usually live in colonial

An Indian burning incense and copal (a tropical resin) at a stone shrine. Many Indians in Guatemala still worship their traditional gods—particularly in rural areas.

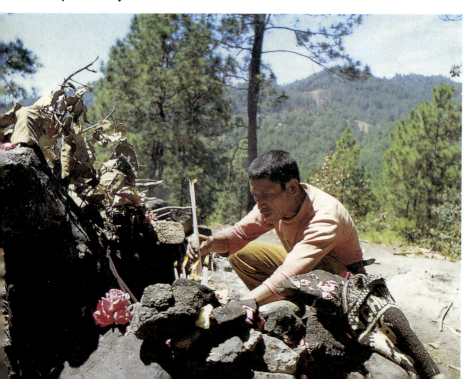

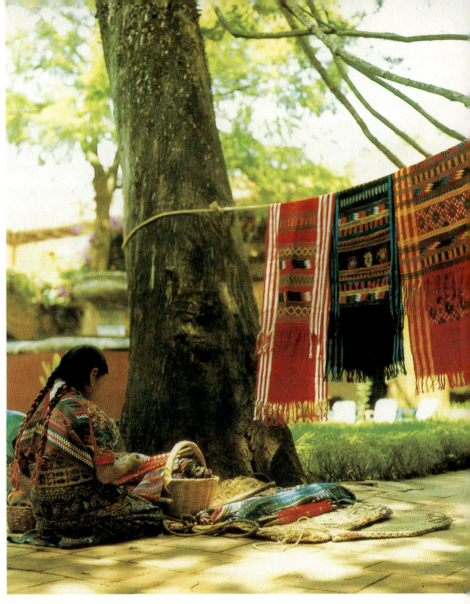

An Indian woman weaving the colorful and unusual textiles for which Guatemala is so famous.

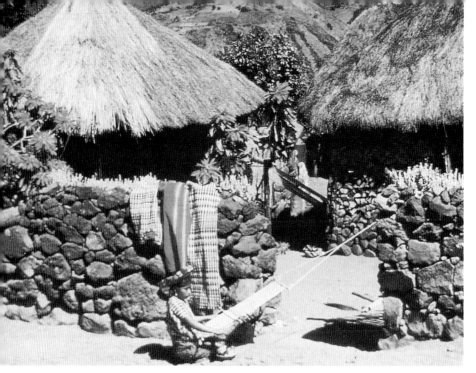

Simple Indian huts in the highlands of Guatemala, built of adobe (sun-dried bricks) as they have been for centuries.

houses or modern apartments. They expect a much higher standard of housing than a poor agricultural worker who often has to sleep and eat in the same room. However, not all the inhabitants of Guatemala City are so fortunate. With more and more people flocking to the capital in search of work every year, the price of housing has soared. Many very poor families cannot afford to pay high rents and they are forced to survive as best they can in slums or shanty towns on the outskirts of the city.

Both the birth and death rates in Guatemala are high. The

46

population is increasing at a high rate. Public health has greatly improved and diseases such as malaria are now much rarer but still a threat. In the 1980s, the Ministry of Public Health began establishing rural health centers with medical staff trained in preventive medicine. There is also national medical insurance provided for most medical problems.

General Justo Rufino Barrios introduced compulsory free primary education in the 1880s. Although education is not on a par with the progressive system in Costa Rica, illiteracy figures are now gradually being reduced. Many more educational

A shanty town on the outskirts of Guatemala City. As more and more people flock to the cities in search of work, so the housing problem increases with many people being forced to live in slums such as this.

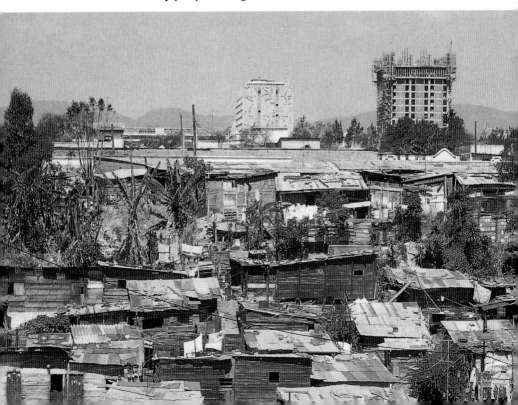

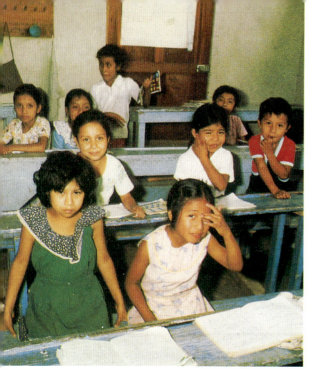

Guatemalan children at school.

opportunities exist than in the days when General Barrios carried out his reforms. Most Guatemalans attend school between the ages of five and fifteen.

The cuisine of Guatemala is very much like that of other Central American countries in that the cooks of Guatemala use maize a great deal. *Ceviche,* often eaten as a starter and composed of several kinds of white fish marinated in a sharp, vinegary dressing, *camarones* (crayfish) and *empanizadas de carne* (meat fried in breadcrumbs) are seen all over Guatemala. Guatemalans drink soft drinks, mineral water or beer with such dishes. Rum is also popular, either before or after meals.

Restaurants serve a variety of dishes, from international

cuisine to fast food such as hamburgers and local specialties such as *tortillas* (pancakes made from maize flour) and *frijoles* (beans). For desserts, there are fritters made from maize over which syrup is often poured, and *quesadillas* (cheese cakes).

There are a great variety of sporting activities in Guatemala. In the coastal areas, water sports such as swimming, waterskiing and snorkeling are popular. In the lake areas, swimming, fishing and boating are enjoyed by many. In the mountains, climbing is a great favorite and is usually done in

An Indian woman cooking *tortillas* (maize pancakes)—a Guatemalan specialty.

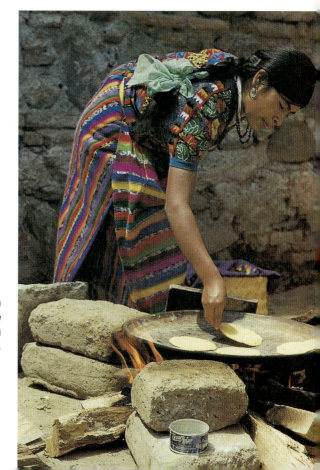

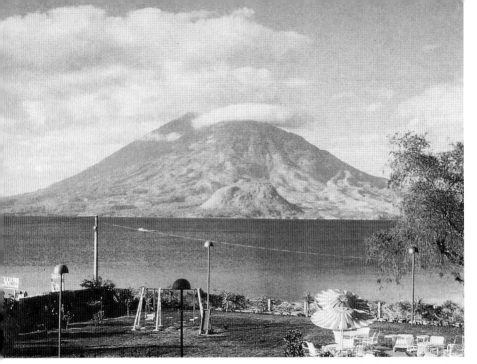

Mountaineering is a popular sport. The volcano Atitlán (*shown here*) is the most challenging peak to climb.

the dry season. Volcano Atitlán, 11,565 feet (3,527 meters) high, is the most difficult climb. Few people would tackle it in the rainy season, as clouds and rain make the ascent (which takes between ten and twelve hours in good weather) extremely hazardous.

Other common pastimes include cycling and horseriding, and there are many trails throughout the country through beautiful and varied scenery. Birdwatching is also immensely popular—in the lake areas alone, there are no less than one hundred and fifty different species of bird, including mockingbirds, jays, woodpeckers, hummingbirds and all kinds of waterfowl. The

50

Lake Atitlán grebe is the rarest waterfowl in the world because it is found only on Lake Atitlán, so every ornithologist tries to spot one!

Just as Guatemalans participate in various sports, so they work in different kinds of jobs. Let's see how they go about earning a living.

5

Earning a Living

Agriculture plays a dominant role in Guatemala's economy and two-thirds of the population live in rural areas. Because the soil is volcanic and highly fertile, a great variety of crops can be grown. The main crops are coffee, cotton, sugar cane and bananas. Maize (the staple diet of most Guatemalans) and beans are also produced, while tobacco, grain and fruit grow in abundance. The production of cereals is being promoted and developed by the National Agricultural Institute, and the Ministry of Agriculture keeps a sharp eye on farming.

Agricultural products account for over sixty percent of exports. Coffee production alone accounts for twenty-three percent, bananas for almost eight percent, and sugar for about nine percent. Cocoa is another important crop. *Chiclé* (chewing gum) is also exported in great quantities, as are tropical fruits such as coconuts, pineapples and citrus fruits.

The departments of Alta and Baja Verapaz are Guatemala's chief coffee-growing areas. The great coffee plantations which typify the area are a vital source of income for the country. The

A woman working on a coffee plantation. Coffee is Guatemala's major crop, accounting for thirty-two percent of all exports.

soil here is extremely fertile and the climatic conditions are ideal. Vast areas of land in these two departments are also given over to the growing of jute, vanilla, sugar cane and spices such as cinnamon.

The department of Escuintla accounts for about twenty percent of the country's coffee output and a large percentage of its cotton production. It also produces sugar cane, and can claim three-quarters of the country's cattle.

Market gardening and flower production have been developed

Ox-drawn carts laden with sugarcane—one of the major crops in Guatemala's Pacific coastal region.

in an attempt to reduce Guatemala's reliance on coffee production as a source of income, and both are steadily increasing production.

Stockfarming is also a valuable source of income for Guatemala. The land is fertile and the highlands are ideal for sheep rearing. It is estimated that there are about two million head of cattle in Guatemala, and there are large cattle ranches throughout the country. Pigs and goats are raised too. The beef

and dairy industries are both doing well—the annual output of beef is currently around 80,000 tons and milk production around 600 million liters (over one hundred and thirty million gallons).

Guatemala's forests produce many kinds of wood including mahogany, ebony and rosewood. These also play their part in the export markets.

Fishing is another area in which Guatemala may thrive. The spiny lobster provides a good source of income. Guatemala has three companies operating off the Pacific coast which greatly contribute to the fishing industry. Lobsters are deep frozen at Champerico on the Pacific coast and sent to the port of Santo Tomás de Castilla where they are exported. The government is doing its utmost to develop the fishing ports still further.

Guatemalan industry has not yet developed on a wide scale. The country has only one oil refinery and limited power supplies. Local industries include cement, cotton, paper, pharmaceutical products, rubber and leather goods, plastics, cigarettes and cigars, mineral water and soft drinks. The United States is Guatemala's principal supplier. Most of Guatemala's exports go to the United States, the countries of the Central American Common Market and Japan.

Recently, oil has been discovered in Alta Verapaz, and oil exploration will certainly develop in the next few years. A large-scale nickel mining project is under way, and salt extraction

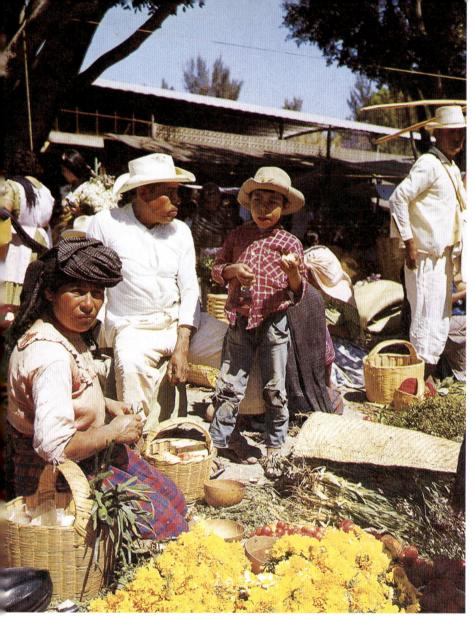

Flowers and vegetables on sale in a local market. The government is encouraging a steady increase in market gardening.

from the sea is already well organized. Copper, silver, zinc, lead and tungsten (a rare metal) are being mined. Guatemala also possesses small deposits of other minerals but these are not sufficient to make a great contribution to the economy.

Many people are now beginning to leave the rural areas where wages are low and prospects limited to look for better-paid jobs. Mining centers, such as Huehuetenango with its silver and copper deposits, and the port cities all need labor forces. However, as more and more people crowd into Guatemala City and other large towns, the already serious housing shortages are further aggravated. As a result of this, the cost of

An Indian boy knitting in the street. In the poor Indian families everyone who can work must do so to ensure survival.

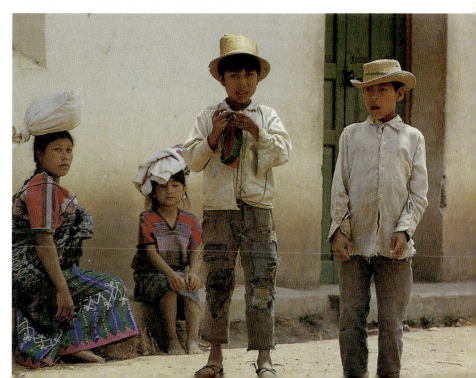

accommodation soars. Unskilled workers are the hardest hit, for even if they manage to find employment in the cities, they will still be the lowest paid. Thus shantytowns arise on the outskirts of cities, in which large families survive as best they can. Despite this, the lure of the cities continues, with more people arriving in Guatemala City (already the largest capital in Central America) every year.

6

Guatemala City

Guatemala City, the capital of Guatemala, lies in a valley at an altitude of 4,800 feet (1,493 meters). It is the largest capital in Central America, with a population of 1,167,495. It lies in the earthquake belt, and has suffered at least three major earthquakes—in 1917, 1918 and, most recently, in February 1976. After the 1918 earthquake, almost all the city had to be rebuilt; and during the last earthquake so much damage was done that it took several years to restore it completely.

Guatemala City was founded in 1776 and replaced the first capital, Antigua. Just when the new capital was developing, the first of the earthquakes shattered the city. As a result, only a few colonial buildings have survived to give a glimpse into the city's past. Today, Guatemala City is an almost entirely new city composed of skyscrapers, brand new office blocks, international hotels and broad avenues.

Guatemala City is laid out in a regular plan and comprises *avenidas* (avenues) running north to south, and *calles* (streets)

which run east to west. The city is interspersed with cross sections known as Diagonals, and is divided into twenty zones.

The oldest neighborhood of the city, known as the *Parroquia Vieja* (the Old Parish) has lost many buildings in successive earthquakes. Today, it is still a quaint neighborhood where residents sit out in the hot, sultry evenings exchanging gossip and discussing the day's events. The old church of Cerrito del Carmen in the middle of the Old Parish is perched on top of a hill from which there is a good panoramic view of the rest of Guatamala City.

The oldest surviving buildings in the city are to be found in Zone 1. Within this zone is the Central Park, which is the city's center. There stands the imposing Presidential Palace, built in a medley of styles which range from Moorish to colonial. The

Buildings were damaged in the 1976 earthquake. Guatemala lies in the seismic zone of Central America, and few of the original colonial buildings have survived the successive tremors and earthquakes.

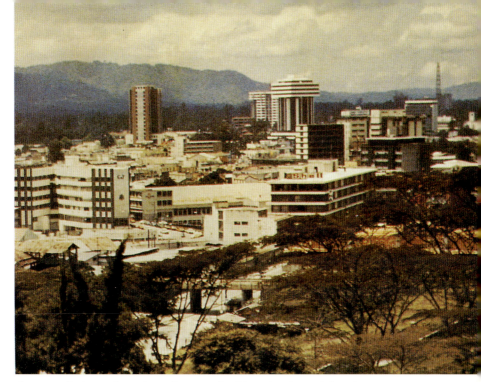

A general view of modern Guatemala City, dominated by skyscrapers and office blocks.

interior has marble floors and carved wooden doors, and the rooms open onto a patio.

To the east of Central Park is the Metropolitan Cathedral, begun in 1782 and not completed until almost half a century later. It has six aisles and sixteen altars, and it is easy to imagine how awe-inspiring it must have looked on completion. Sadly, the cathedral was damaged during the 1976 earthquake.

As so often happens in Latin American countries, Guatemala's Metropolitan Cathedral used to have a market (the Central Market) right beside it. The market was of great

61

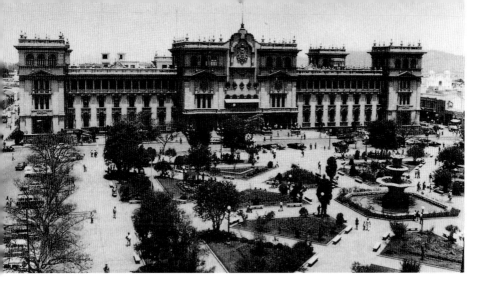

Central Park and the Presidential Palace in Guatemala City.

interest—especially to visitors, as typical handicrafts were displayed alongside such local produce as tropical fruits and vegetables. It was made the more picturesque by the arrival of Indians from neighboring communities who wore their regional costume. After an earthquake destroyed the area, the Central Market was split up into different sections and relocated in various parts of the city—but it is just as colorful as ever, even if it is now divided.

Guatemala City has many churches and city parks. The church of Santo Domingo is dedicated to the patron saint of Guatemala, while the church of Santa Rosa was used as the city's cathedral when the capital was transferred from Antigua to Guatemala City in 1776. Most of the city's churches are built in the classical style. One exception to this is the modern-looking Church of Atonement. One of the city's more unusual churches

62

is the Yurrita Church, also known as *Nuestra Señora de las Angustias*. This is a mixture of architectural styles ranging from Moorish to baroque. It has four large turrets which make it seem more like a fortress than a church.

Each city zone is different from the next. In Zone 4 is the Mateo Flores stadium, where thousands of fans go to watch soccer, the undisputed national sport. The stadium can seat up to 50,000 spectators and is the venue for both national and international matches.

General Justo Rufino Barrios is remembered at one of Guatemala City's best-known landmarks, the Reformer's Tower. This is a 230-feet (70-meter) high steel construction,

The Metropolitan Cathedral, begun in 1782, undergoing restoration following the 1976 earthquake.

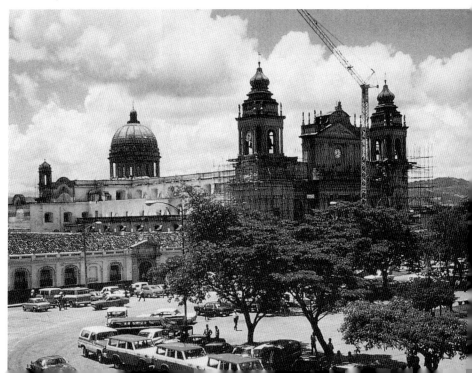

similar to the Eiffel Tower in Paris, supported on four piers over
one of the city's main thoroughfares, the *avenida de la Reforma*.
This avenue is an elegant, wide boulevard lined with trees,
embassies, luxury hotels and fine old houses. It is also the area
where smart Guatemalans shop in the boutiques. This is a
middle class, residential area, its well-maintained homes a
complete contrast to the rundown shacks of the poor. The
president's house is situated here, and the avenue is fittingly
studded with monuments. Open-air cafés make the *avenida de la*

Reforma a pleasant place to stroll in, and many Guatemalans as well as visitors do so whenever the occasion arises.

The commercial center of the city is Sixth Avenue, running through Central Park. It is crowded with shops selling all kinds of merchandise, vying with each other for attention as they compete for business with the newly-built shopping plazas, restaurants, bars and hotels. Many visitors like to stroll down Sixth Avenue, doing nothing in particular except window gazing, just to soak up the atmosphere. At night, lines form outside the cinemas and, even after dark, Sixth Avenue is as crowded as ever.

In Zone 7, on the outskirts of the city, lies the ruined Maya city of Kaminaljuyu. This is thought to have been influenced by the Maya of Mexico, builders of the great temples of Teotihuacan, near Mexico City.

There are various ways of getting around in Guatemala City. Buses are cheap but by no means comfortable. They are usually overcrowded and stiflingly hot and sticky. As streets in the city (with the exception of main thoroughfares such as the *avenida de la Reforma*) are narrow, traffic jams are commonplace. City buses are old and usually falling apart, which only makes matters worse, and suffocating fumes from exhaust pipes pollute the atmosphere. Buses carry all kinds of talismans to ward off danger on the highway. The dashboards of taxis, too, are usually decorated with all manner of charms to protect the driver and his passengers. Taxis can be identified by their license plates, which have a large letter A. Minivans called

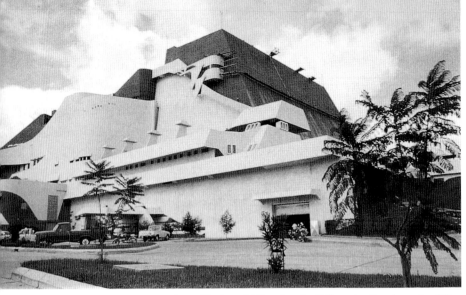

The impressive modern National Theater building in Guatemala City, where drama productions are staged by both national and international companies.

ruleteros also carry passengers, and in addition Guatemala City has a number of car rental firms.

As Guatemala's climate is never unbearable—even in the hottest months of April and May, the days are pleasant, and during the rainy season showers are usually brief, with few of the torrential downpours experienced in other Central American countries—Guatemala City is a pleasant place to live.

Within easy reach of Guatemala City are a number of typical Indian villages. One of these is Chinautla, about five miles (eight kilometers) from the capital, and noted for its pottery. This is handpainted by the women, using the same designs as their ancestors used before them.

San Pedro Sacatepequez is noted for its embroidery, fashioned

by the village women. They sell their designs in the market held in the town on Sundays. Other outlying villages pride themselves on their crafts such as *huipiles* (blouses), with their intricate patterns made in a wonderful range of colors.

How different the modern capital of Guatemala City is from Antigua, the country's first capital.

Onward to the Mexican Border

Lying 25 miles (40 kilometers) from Guatemala City, Antigua, with a population of 30,000, has also suffered great damage from earthquakes. Unlike Guatemala City, however, Antigua is a city of old, historic buildings.

By now, the inhabitants of Antigua have become used to so much

Antigua, Guatemala's former capital, dominated by one of the volcanoes which contributed to its destruction in 1773.

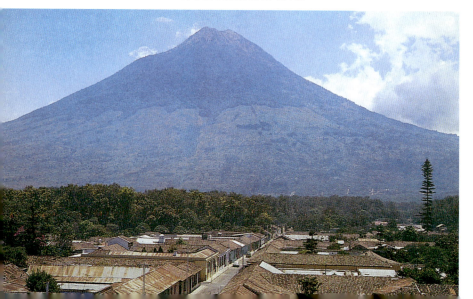

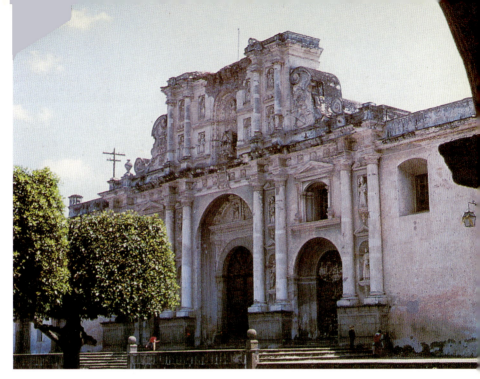

Antigua's cathedral—originally built in 1543, it has since been destroyed on no less than three separate occasions.

building and rebuilding, and yet they still have a feeling it will never end, for the city is ringed by volcanoes which could erupt at any moment. It is a miracle that so much has survived, for Antigua has had to contend not only with earthquakes and volcanoes, but also with severe floods which caused many people to abandon their homes.

Nevertheless, the people of Antigua have come to accept such hazards. No matter what happens, they have to live with it. Even their cathedral has been rebuilt on two occasions, only to be destroyed again in 1773. The cathedral originally had eight

69

chapels, although now only two remain. When the construction of the cathedral was first begun, in 1543, it cost thousands of gold crowns because its interior had to be the best and most dazzling. Many renowned sculptors and artists were brought in to work on the building.

The city's central square is occupied by the Palace of the Captains-General who once controlled the city. The building dates originally from the sixteenth century but has been rebuilt several times. Also on the square is the Town Hall, together with the University of San Carlos Borromeo, in which the Colonial Museum is located. The museum houses relics from the colonial era, including a replica of a seventeenth-century printing press, the first one used in Guatemala.

The University of San Carlos Borromeo in Antigua.

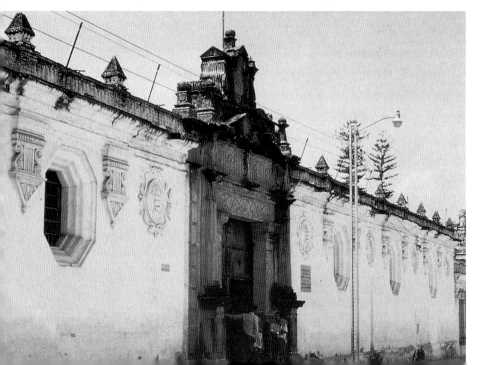

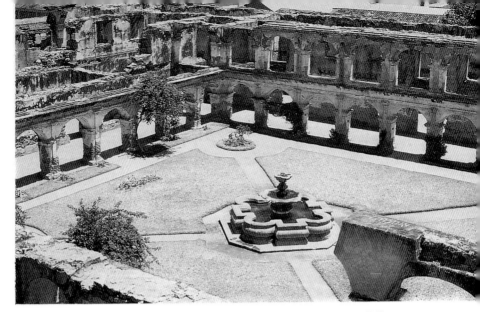

The Convent of Santa Clara, one of Antigua s many historic buildings.

One house attracts particular attention from visitors because it is thought to have once been owned by Pedro de Alvarado, the Spanish conquistador who brought such suffering to Guatemala. The house is called the *Casa de las Campañas* (Campaign House).

Although now in ruins, *Las Capuchinas*, the convent of the Capuchin nuns, dates from the early eighteenth century. It has an interesting history in that it was the only convent in Antigua which women could enter without a dowry. Most convents took in only wealthy young women, but *Las Capuchinas* permitted all who felt they had a vocation to enter.

Another church of interest is the *Recolección*, begun in 1701. It had to be built outside the city, as Antigua already had so many churches that it had no room for another one. The *Recolección*,

too, was damaged in an earthquake, and homeless Indians began to live in its ruins.

Like so many other cities of Guatemala, the time to visit Antigua is during Holy Week festivities, when the whole town comes out to celebrate. The streets are crowded with people reenacting Christ's entry into Jerusalem on Palm Sunday. Citizens dressed as Roman soldiers march through the streets, followed by men and women in purple robes. Then comes the huge float bearing the image of Christ. The parade winds through the town with floats carrying the figures of Pontius Pilate, the Virgin Mary and Mary Magdalene. Then Christ's crucifixion is reenacted, providing one of the most realistic religious festivals anywhere. During Holy Week, all Antigua's hotels are solidly booked. Many people take their chance and sleep where they can in order not to miss the spectacle.

Like Guatemala City, Antigua has some interesting towns within easy reach. Santa Maria de Jesus, built on the slopes of the Agua volcano, gives an idea of how the Maya lived cultivating their crops. Today the villagers still grow maize just as the Maya did, and some of the Indian men wear the traditional suit (*traje*).

Ciudad Vieja (Old City) is where Don Pedro de Alvarado lived with his wife, Doña Beatriz. San Felipe de Jesus is a place of pilgrimage during Lent for it is then, just before Holy Week, that scores of pilgrims descend on the town seeking miracles and cures.

Another interesting town is San Antonio Aguas Calientes. This

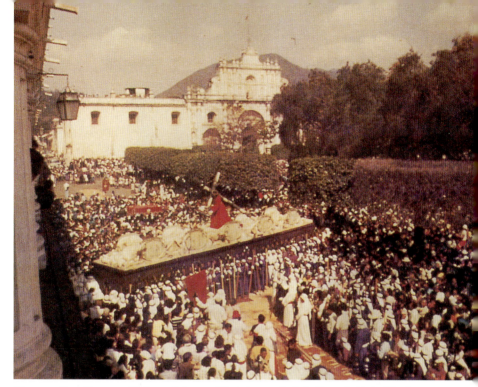

Re-enacting the crucifixion of Jesus Christ—part of Antigua's Holy Week festivities, attracting vast crowds of visitors.

is an ancient farming community which lives by its agriculture and textiles, many of which are to be found in the shops lining the main street. *Huipiles* are a feature of San Antonio, along with many examples of skillfully made woven goods which are usually beautifully decorated with a variety of patterns.

The Pan American Highway goes westward to Quetzaltenango, the main town of the department of the same name. It is Guatemala's second largest city, with a population of about 88,700. Quetzaltenango, which means "land of the quetzal," has a

The quetzal, the emblem of national sovereignty, as it appears, on a restaurant sign.

cool climate compared to the sultry, steaming coastal plains, as it is situated 7,656 feet (2,334 meters) above sea level, near the foot of the Santa Maria volcano and the active Santiaguito volcano on its southwestern side. Founded by the Spanish conquistadors, it is of special historic interest because it is built on the site of a city which had been there thousands of years before and is thus pre-Columbian. It is Guatemala's second largest city and it is the commercial center for southwestern Guatemala, producing textiles, wool and shoes as well as liquor.

Unlike Guatemala City with its noisy traffic jams, Quetzaltenango is quiet and dignified. Like Antigua, it preserves a colonial air despite the damage it has suffered in numerous earthquakes. Its squares and streets are reminiscent of past times and its people go about their business in an unhurried fashion.

Quetzaltenango is the gateway to the Pacific ports and is the town to which the Indians come to trade. The Indian community is often found wearing traditional costume, the men in *trajes*, the women in *cortes* (long, pleated skirts).

Guatemala's principal Indian center, however, is the department of El Quiché, north of Quetzaltenango. The capital of the department is Santa Cruz del Quiché, with a population of 13,000, which holds its markets on Sundays. It is also the town of a fiesta, held from August 16th to 20th. Simply called "El Quiche," the town is more quiet and more typical of the Guatemalan countryside.

The department of El Quiché possesses many interesting towns and villages, most of which hold Saturday markets where fruit and vegetables can be bought. Some villages sell typical

Market day in Quetzaltenango, the town where the Indians come to trade, often dressed in their traditional costume.

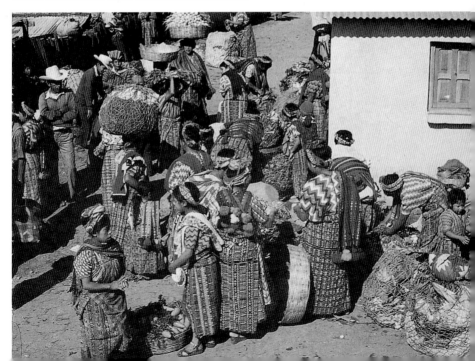

Indian handicrafts. One village of particular interest is Sacapulas, which lies on the Rio Negro (Black River) and produces salt. It too has a typical market, and a fine old colonial church.

But the town of most interest to visitors to El Quiche is Chichicastenango, with a population of 8,000. This lies 90 mile (145 kilometers) from Guatemala City and holds fiestas at which the Indian community dress in their most colorful attire. Before the arrival of outsiders, Chichicastenango maintained its thoroughly Indian traditions and way of life, but today these have been sadly eroded by so many tourists invading the town. Nevertheless, the local Indians still preserve many of their old ways, and hold traditional religious festivals.

A group of children in Chichicastenango.

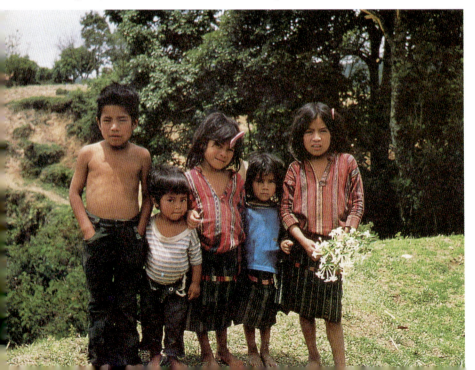

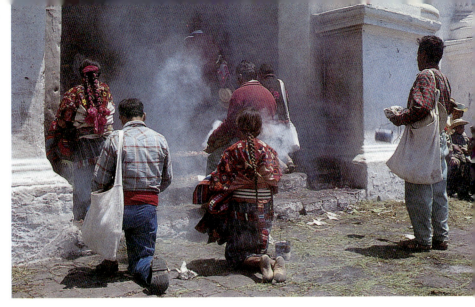

Indians burning incense outside the church in Chichicastenango.

Chichicastenango is four hundred years old and it is estimated that over four thousand Indians live in the surrounding hills, coming into town for festivals and markets. They go about their business quietly and unobtrusively and with good humor. During religious ceremonies, incense is burned as the Indians make incantations to their ancient gods. They come with offerings of fruit, amidst the flickering candles, mumbling their prayers as they go.

From Quetzaltenango to Chichicastenango, the road passes through Totonicapán, the smallest department in Guatemala and another Indian settlement. Its chief town, Totonicapán, has a population of around 13,000 and lies at an altitude of 8,200 feet (2,500 meters), and is situated 15 miles (24 kilometers) from Quetzaltenango.

The people of Totonicapán are skilled craftsmen producing fine jewelry and textiles and costumes for use in festivals and celebrations. Craftsmen are fortunate in that the forests of the region produce high-quality timber. Brightly-painted chests in their bold "traffic light" colors of green, yellow and red are a feature of the town.

Indian villages which exist by practicing ancient skills are very much alive today in the remoter areas of Guatemala. It is to be hoped that such communities will continue, for Guatemala would not be the same without them.

Lake Atitlán and the Coastal Regions

Lake Atitlán is one of Guatemala's most famous beauty spots. Situated at an altitude of over 5,128 feet (1,563 meters), it is ringed by the volcanoes Atitlán, Toliman and San Pedro. The lake is a caldera (collapsed volcanic crater). The lake is 1,049 feet (320 meters) deep, 6 miles (10 kilometers) wide and 12 miles (19 kilometers) long, with an area of 49.3 square miles. Fish in the lake are abundant, and even crabs can be caught there.

Dugout canoes, *cayucos*, on Lake Atitlán.

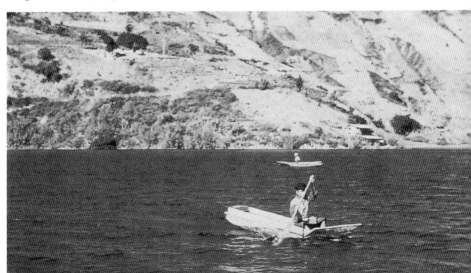

The lake itself changes color throughout the day. It starts off clear and tranquil but, by midday when the wind which the Indians call *Xocomil* blows up, the surface of the lake becomes choppy, making journeys by boat risky. There are many Indian myths about Lake Atitlán. Hot springs spurt out of its banks and the changing patterns of the lake are attributed to this thermal activity. Sometimes the water looks blue, sometimes green or purple, while white candyfloss clouds rise round the peaks of the three volcanoes—the highest, Atitlán, reaches 11,565 feet (3,537 meters). When the *Xocomil* gusts, the Indians stay at home tending their crops and do not venture out in their *cayucos* (dugout canoes) to take their vegetables to market. Generally, however, the lakeside climate is ideal with fine, warm clear days and cool nights.

The Indians of the area grow the staple foods of Guatemala—maize and beans. Due to the mild climate, many fruits and vegetables which would not grow at higher altitudes or in the sweltering coastal plains are also grown in the Lake Atitlán area. A visit to a local market reveals lemons, oranges, pineapples, avocados, onions, succulent strawberries, ripe tomatoes and apples. Coffee also grows well in the region.

There are twelve villages in the lake area, separated from the rest of the region by towering volcanoes. Once isolated from the outside world, such villages are now beginning to experience change, brought about by more and more visitors to the area. Old traditions die hard, however—*brujas* (witches) can still be found in such communities and are regularly consulted.

80

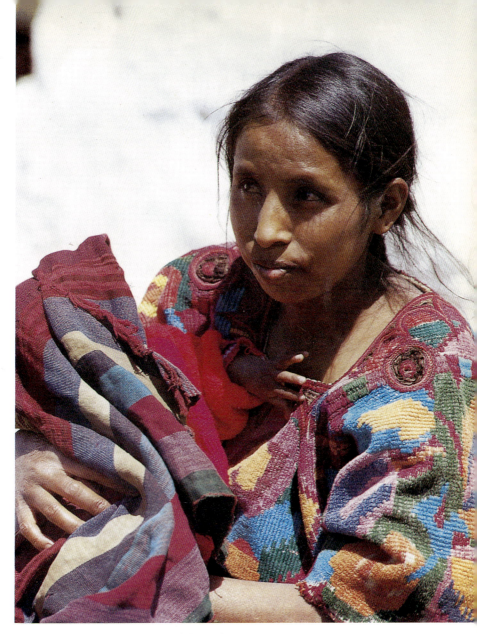
An Indian woman in her colorful hand-woven costume.

An Indian man wearing *trajes*—the usual sober black trousers and white shirt—at a local market.

The costumes of the Indians are brilliantly colored, with the women wearing the most colorful costumes of all. These combine the traditional colors of red, black, white, blue, bright orange, yellow, purple and green just like the brilliant flowers and citrus fruits of the area. The women dress themselves in traditional *huipiles* (blouses) and *cortes* (skirts) with sashes and headgear.

So that the women's dress, which is as gaudy as a parrot's plumage, may be seen to advantage, the men's *trajes* are more sober. They usually wear black trousers and white shirts—but even they sometimes wear traditional embroidered *pantalones* and colorful sashes.

Each village has its own particular designs, so that villagers can

easily identify each other. Each village grows different crops too, in addition to the staple foods. One may specialize in tomatoes, another in avocados, yet another in citrus fruits. The village of San Antonio, for example, grows anise.

Each village also concentrates on a particular craft. San Pablo makes ropes from the fibers of the agave plant; San Antonio uses reeds to make mats; Santiago makes *cayucos* (dugout canoes), while other villages make brightly patterned rugs. A difference can also be observed in the people of each village. Some have lighter skins than others, and different facial

A bean-seller in a local market weighing out black beans (*frijoles*), a staple food in Guatemala.

characteristics, yet their strong sense of community gives them a common bond.

Panajachel is the largest of the twelve villages, with a population of 5,000, and its Sunday market brings in the Indians from the surrounding areas who transport their goods to be sold. The villagers manage to be self-supporting. Their farming methods enable them to live on their crops of coffee, garlic, maize and fruit.

The villages all look different but all are well maintained and present an attractive appearance. Santa Catarina Palopo, three miles (five kilometers) from Panajachel, is a village of thatched roofs, lying in a valley, while San Antonio Palopo, considered to be the most picturesque, clings to a rocky outcrop rising from the

A view of San Antonio Palopo, considered by many people to be the most picturesque village in the Lake Atitlán area.

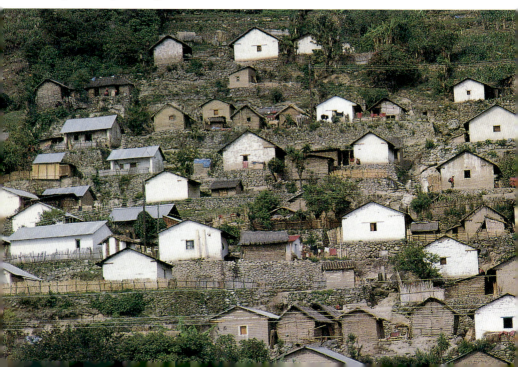

Indian-owned fields near Sololá on the Pan-American Highway.

lake. As so many onions are grown there, their odor pervades the village.

Santiago Atitlán was the ancient capital of the Tzutuhils tribe, and its stone streets and waysides blooming with cacti, its thatch-roofed houses and bamboo huts give a picturebook impression. In Santiago, the women do their washing in the lake, and their colorful clothes can be seen hanging out to dry. The villages are reached by *cayucos*, on foot or by horse or donkey.

Sololá, with a population of 9,000, is situated above Lake Atitlán, five miles (eight kilometers) from Panajachel on the Pan American Highway. Sololá's market enjoys a fine reputation

85

and is one of the most picturesque in the whole region. Everyone brings his wares to Sololá. The Highlanders bring their reed mats, exquisitely woven blankets and pottery, while the Lowlanders bring sugar, bananas, dried fish and spices, so that all can exchange merchandise and profit from each other's labor.

West of Lake Atitlán, on the Mexican border in the department of San Marcos, the town of San Pedro produces a woven cloth which is sold in the local markets and much sought after for its bright yellow color.

Lake Amatitlán, an area many Guatemala City residents go to for weekends, lies 19 miles (25 kilometers) from the capital and is crowned by the Pacaya volcano. In the region of the lake lie a number of Indian villages which also hold markets to sell their wares.

Escuintla, the chief town of the department of that name, lies 28 miles (45 kilometers) from Guatemala City. Due to its rapid expansion, it is now one of Guatemala's largest cities with a population of 62,051. It produces coffee, sugar cane and cotton, and raises cattle. On Escuintla's coast lies Puerto San José, Guatemala's second largest port after Puerto Barrios, with a population of 14,000. Like the town of Escuintla, San José is also a big producer of coffee, bananas and sugar. San José is a typical, sunbleached seaport. Like many such port cities, it has a ramshackle air. The rundown shacks in which the dockworkers live, the dirt streets usually overrun with stray dogs, the smell of rum from the bars, the odor of salt from the sea and the smell of fish all combine to let you

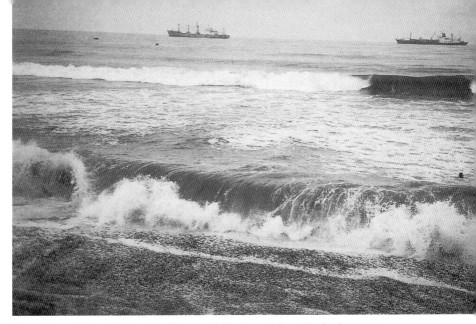

Container ships off San José, one of Guatemala's principal ports.

know you have entered a dockland area. The dockworkers are a cheerful, amiable bunch of people who take life in leisurely fashion in their hot, humid surroundings. The sound of *marimba* music can be heard at night in the darkening streets. San José lies open to the ocean with its ships at sea ready to offload their cargoes onto large open boats which in turn unload the cargo on the wharf.

Iztapa, about 12 kilometers east of San José, was Guatemala's first Pacific port. From there, Don Pedro de Alvarado set sail for Mexico on the ill-fated expedition during which he died. Iztapa is overcrowded at weekends, and by midday the beaches are swamped by hordes of Guatemalans who are trying to escape the city. Such beach towns have an abundance of freshly caught

87

seafood which can be sampled in the local restaurants or at fast food stands.

The Atlantic Highway connects Guatemala City with the Caribbean seaports of Puerto Barrios and Santo Tomás de Castilla. Puerto Barrios is Guatemala's most important port, and bananas, one of the country's main crops, are exported from here.

The Atlantic Highway also provides access to the largest of Guatemala's lakes, Lake Izabel, surrounded by tropical vegetation. The lake is 33 miles (53 kilometers) long and 18 miles (29 kilometers) wide and has warm blue water. It is ideal for fishermen as all kinds of fish are found there. The Castillo de San Felipe, a great stone fortress built originally at the end of the sixteenth century to repel pirate attacks, stands at the entrance to the lake. It was built to guard Lake Izabel, for the lake was once an important trade route to Europe by way of the Dulce River. Consequently, it was attacked on several occasions by British, French and Dutch pirates, determined to lay their hands on what they supposed to be Spanish gold. At the end of the seventeenth century, the fortress was used as a prison, after which it stood empty for many years. Guatemala's shortest river, the Dulce River, flows from Lake Izabel through jungles until it empties into the Caribbean, where the town of Livingston is situated.

A population of over five thousand black Caribs (Garifuna) inhabits the town, Livingston, which is noted for its brightly painted wooden houses. These Caribs are a mixture of

88

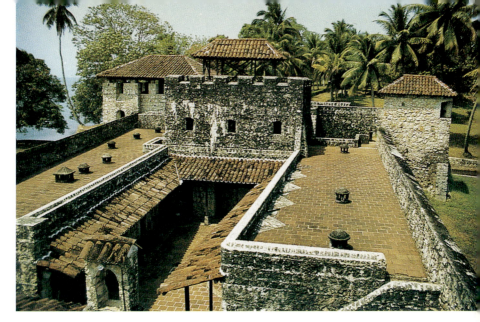

The Castillo de San Felipe, a sixteenth-century stone fortress built to repel pirate attacks. It stands at the entrance to Lake Izabel.

descendants of African slaves, brought to the West Indies by the British, and the Carib Indians. They speak English in a lazy, singsong drawl and are a happy-go-lucky people whose origins stem both from Africa and the West Indies—a blend of cultures which is reflected in their music.

Before Puerto Barrios was created, Livingston was the only outlet to the sea and therefore of great importance. Coffee from the plantations of Alta Verapaz was sent there for export, as were bananas. Thus Livingston became the most significant port on the Caribbean coast. These days, the fine sandy beaches of the Caribbean attract snorkelers and divers as well as fishermen. The town's bars serve strong, fiery rum. The black Caribs are getting used to visitors but nothing changes their freewheeling lifestyle.

After Puerto Barrios, the next largest provincial town is Mazatenango, with a population of 38,000. From Mazatenango, the road runs via Retalhuleu, a coffee and cotton-producing area, to the port of Champerico. After Mazatenango, the next largest of Guatemala's towns is Chiquimula, the chief town of the department of that name, with a population of 24,000. Chiquimula's colonial church has stood in ruins since the eighteenth century but its daily market best illustrates the life of the town. All kinds of local wares are displayed, and it gives the townspeople a chance to meet and exchange ideas as well as buy, for Chiquimula is noted for its fruit and vegetables.

From Livingston, the road goes north to Poptun and on to Flores, the main town of the department of El Petén, with a population of about 2,000. The town is built on an island on Lake Petén-Itza. Once Flores could only be reached by *cayuco*, but a causeway now connects it with the mainland. As it is situated on an island, Flores is unable to expand further. In a way, this is fortunate, for it is able to preserve its isolated atmosphere of narrow streets and "old world" charm.

9

Looking Towards the Future

Following the establishment of Guatemala as a republic, there was a long period of almost continuous political unrest. One dictator after another was overthrown, emphasizing not only Guatemala's political instability but also its shaky economic situation.

Just when the country seemed to be settling down, Guatemala was devastated by the earthquakes of 1917 and 1918 which left behind them a trail of disaster, loss of life and terrible damage to buildings. Towns were unrecognizable, especially the capital, Guatemala City. Money was needed to rebuild whole cities. With an ailing economy, how was the money to be found?

There were those who wanted to move the capital yet again, to a place where earthquakes could do no more damage, but Guatemala City remained Guatemala's capital. Reconstruction was undertaken on a massive scale. Guatemala City was starting to turn into the bustling, modern city we know today. But what about economic progress? Guatemala had to move forward to

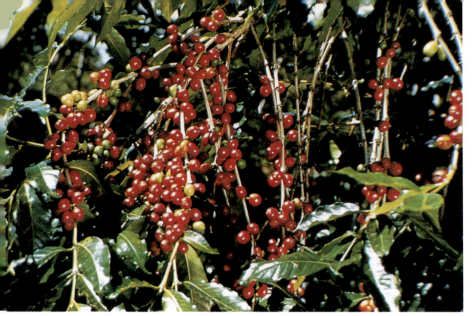

Coffee cherries—the beans are the seeds inside the cherries. Coffee is one of the principal sources of income for Guatemala.

stay in line with progressive, expanding countries which had a strong economy.

Guatemala had relied on coffee, its major export, for so long that it suffered when coffee prices fell. Trade figures dropped. Added to that was the massive earthquake which ripped the republic apart in 1976, causing severe damage to the country. But the banana plantations operated by the United Fruit Company were in full production, and today the banana remains a vital source of foreign money.

The civil war which lasted 36 years tore apart the country. The peace accord signed in 1996 tried to address the plight of the poor and displaced people of Guatemala and the rights of the people to health care, education and basic social services. But the

civil war left over a million people homeless and hundreds of thousands dead or missing. A lasting peace will only occur if the inequities in the social and economic structure of the country are addressed. These inequities are great with a large percentage of the Guatemalan people living in poverty and misery.

Wages are low, especially in the rural areas, but exports are a way of making the country richer and when that happens the workers, too, will share the benefits. But presently the ownership of land makes life very difficult for the agricultural community as approximately 70 percent of the available farm land is owned by only three percent of the population.

Coffee production is at a high level, and Guatemala's industries are gradually increasing their output. More and more visitors are arriving in Guatemala, and assisting the tourist industry. They come not only to look at Maya sites but also to buy Indian handicrafts which are of a high standard and sell well abroad. While Guatemala can be proud of its Indian connections, it has to advance in a highly competitive modern world where increased productivity benefits the economy. Bananas are shipped abroad from both Pacific and Caribbean ports and the process is now being speeded up. Bananas are a major source of foreign income for Guatemala. Cotton production has already improved. Main agricultural areas such as the departments of Quetzaltenango, Sololá, Alta and Baja Verapaz and San Marcos are being encouraged to step up their production rates. Increased productivity takes time, but recognizing what needs to be done is a step in the right direction. Much land has been cleared to lay

93

the foundations of Guatemala's agricultural centers which today are dotted with large ranches where much of the cattle raising is done. There is great potential in the land which is rich and fertile and ideally suited to the growing of crops. But the clearing of the rainforest by the farmers and ranchers is creating severe ecological problems that need to be addressed.

Linked with Costa Rica, El Salvador, Honduras and Nicaragua in the Central American Common Market, Guatemala enjoys almost completely unfettered free trade with these countries, and has also established trade links with Japan, Germany and the United States. It is largely upon trade links such as these that the future of Guatemala depends; that and the maintaining of political stability.

Given the advances of peace with the ending of the civil war and the growth of the economy, most Guatemalans are optimistic about the future. The country continues to expand and develop rapidly. City growth, and the opportunities which go with it, encourage people to leave rural areas and gravitate towards towns and cities, which in turn creates housing shortages. However, Guatemala is moving towards a healthier economic future which will eventually benefit everyone.

GLOSSARY

caracol Large seashell used as a musical instrument in folksong and dance.

cayuco dugout canoe.

chinchin A musical instrument that resembles maracas.

cortes Long, pleated skirt worn by Indian women.

departamentos Sections of the country divided for governmental purposes.

huipiles Blouses woven on looms.

llanos Prairies.

Los Gigantes Giant human figures dressed as puppets used in fiestas or celebrations.

marimba A musical instrument similar to a xylophone.

mestizos Racial mix of Indian and Spanish.

municipios Municipalities or towns.

ocarina Type of flute used in Guatemalan folksong and dance.

quetzal Unit of currency, also a rare bird of brilliant green, red and blue plumage that is the national

emblem of Guatemala. It is considered a symbol of liberty because the quetzal dies if captured.

salsa Popular dance rythym throughout Central America.

stelae Upright stone slabs on which Mayans recorded important events with picture writing.

tambor Type of drum.

traje Traditional suit worn by Indian men.

xocomil Term used by Indians for the distinctive southeasterly wind.

INDEX